Flowers of Faith

JOANNE FINK

Patterning Basics

The illustrations in this book are designed to be a springboard for *your* creativity—that's why there is a credit line for you, as co-creator, at the bottom of each page. Before you start to color, take a moment to review some of my favorite patterns, which you can

use to enhance the designs. In addition to embellishing what's already on the page, I encourage you to express what's in your heart by adding your own text and illustrations to the designs. I've given you step-bystep instructions.

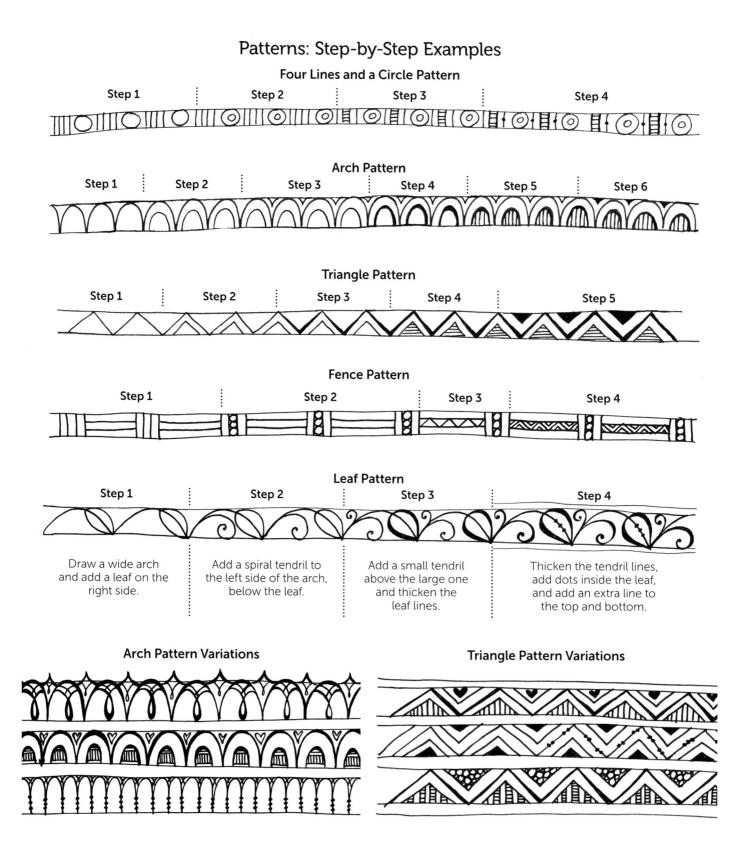

Create, Color, Pattern, Play pages are designed to allow your creativity to shine. You can color each page as-is, or make the design your own by adding patterns and embellishing the illustration.

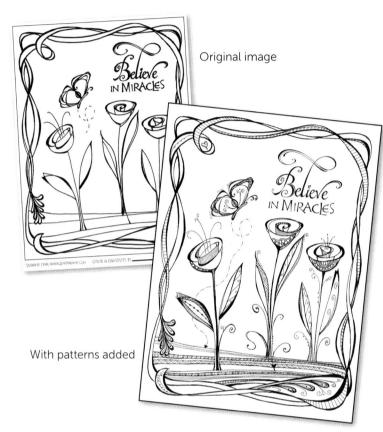

Adding Patterns: Step-by-Step Example

Here are a few simple techniques for enhancing an existing illustration with patterns. You can add as little or as much as you want-be creative!

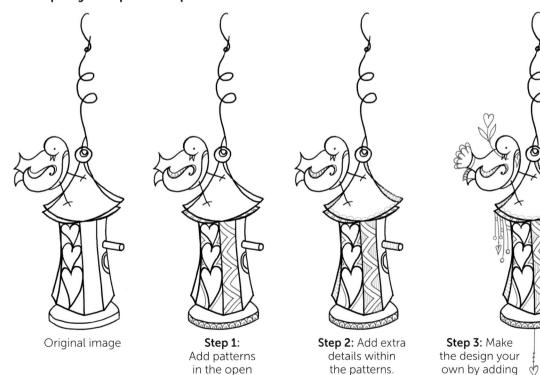

spaces.

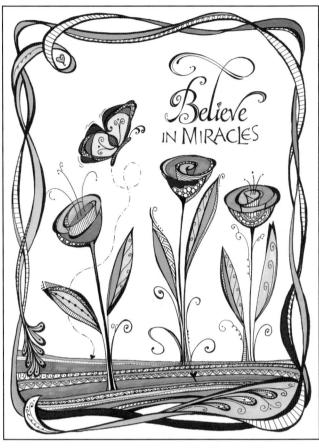

Color and creativity enthusiast Alison Clement used pens to add patterns, then used brush markers to add color to the design.

own by adding on to the existing illustration.

Drawing Basics

You can use a similar step-by-step method to create additional elements to add to one of the pages in this book, or combine several simple drawings to create your own design. Try drawing and patterning the cloud, snail, and flower icons below. Notice how they are incorporated into the scene on the next page. Practice creating a similar scene using your favorite icons.

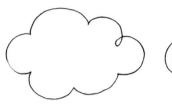

Step 1: Draw the shape.

Step 2: Add lines to create spaces around the perimeter.

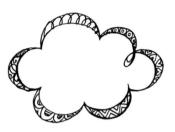

Step 3: Add patterns inside the perimeter spaces to create interest.

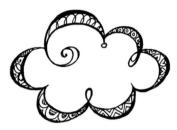

Step 4: Finish by adding weight to the exterior lines. If desired, enhance by adding your own special touches, such as the spiral, dot, and loops in the cloud and the face and antennae in the snail.

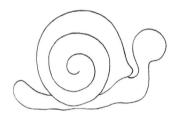

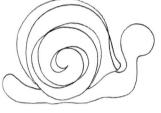

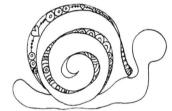

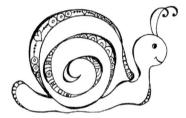

How to Draw a Funky Flower

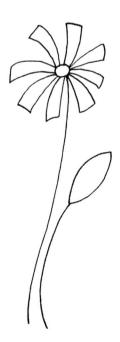

Step 1: Start with a simple drawing.

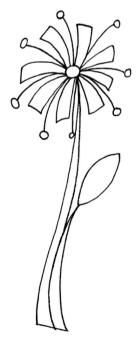

Step 2: Add a line with a circle at the end between each petal. Add a second line to fill out the stem and leaf.

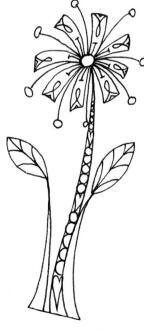

Step 3: Add small, simple patterns to the petals, leaves, and stem.

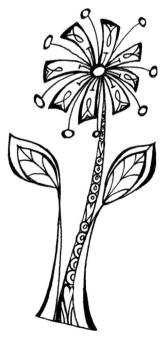

Step 4: Finish by thickening some of the lines.

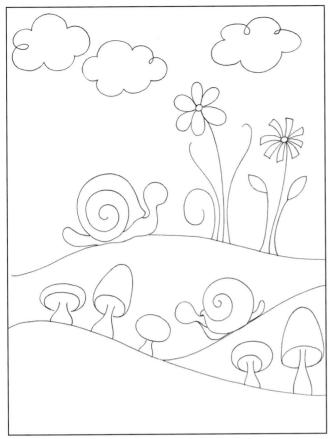

Step 1: Draw the scene.

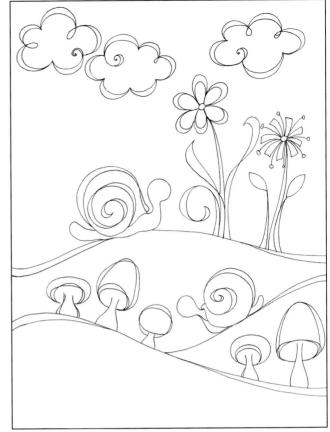

Step 2: Add lines to create spaces around the perimeter of each icon.

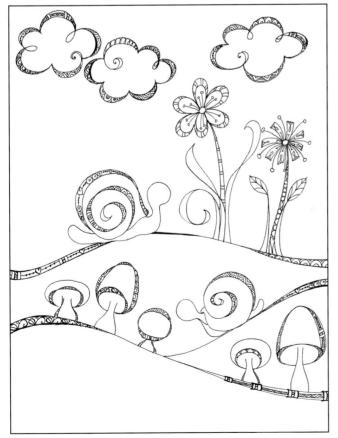

Step 3: Add patterns inside the perimeter spaces to create interest.

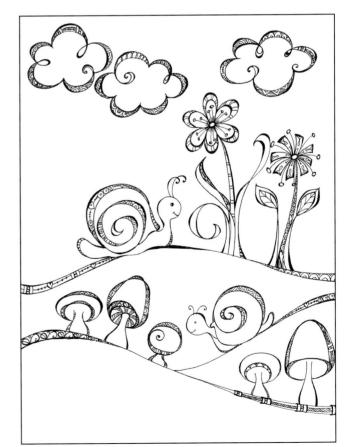

Step 4: Add weight to the exterior lines and finish by adding your own special touches.

Making the Design Your Own

The same design can be interpreted many different ways. You can adapt the designs in this book as little or as much as you want—be creative! Here are some examples for inspiration.

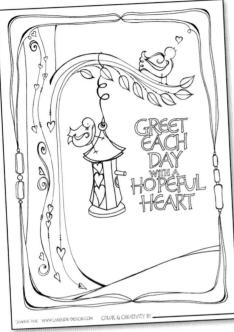

Original image

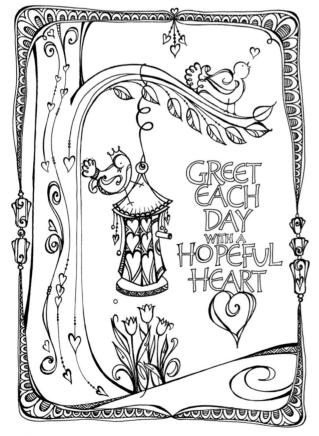

Variation 2: Patterning and dangles added to birdhouse and border; patterning added to leaves; feathers added to birds; flowers added below birdhouse; swirl added to hill; heart added below lettering.

Variation 1: Patterning added to birdhouse and beads; leaves added to tree; hill and sun added to landscape; heart added to bottom border.

Variation 3: Enhanced lettering with dangles and flourish; name added above branch; flower added in bird's mouth; patterning added to leaves; sun added to landscape; patterning added to left side of tree trunk.

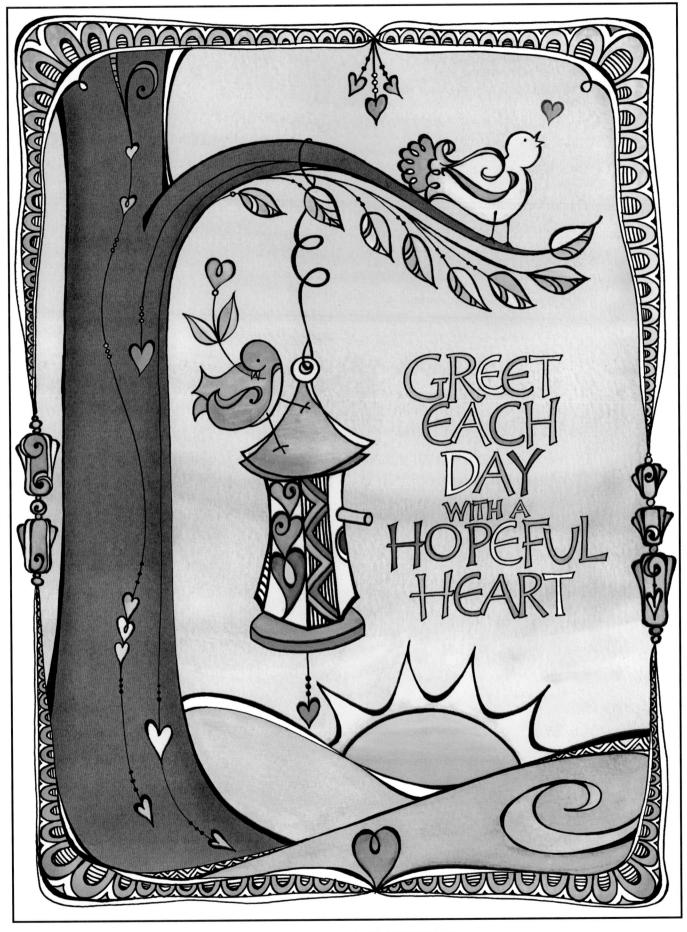

"JOANNE FINK WWW.LAKESIDE-DESIGN.COM COLOR & CREATIVITY BY

Special thanks to color and creativity enthusiast Samantha Trattner for her lovely watercolor version of this design.

Coloring Basics

The icons on these pages have been colored and patterned using different coloring mediums, each producing different effects. I recommend experimenting with different mediums on scrap paper to help find the ones you prefer before applying them to your designs. Don't feel like you must color every part of a design. I often leave a few areas of white in my images, especially in the patterns.

Colored with colored pencils. Blended with artist odorless mineral spirits and blending stump.

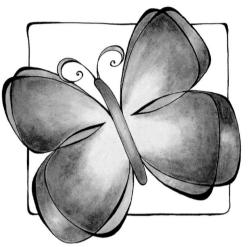

Colored with water-soluble pencils. Blended with blender brush pen.

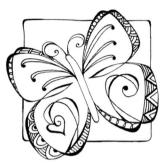

Patterned with black pen.

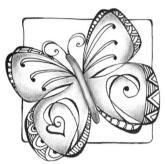

Patterned with black pen. Shaded with graphite pencil.

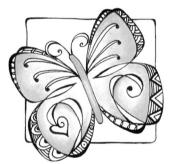

Patterned with black pen. Colored with colored pencils.

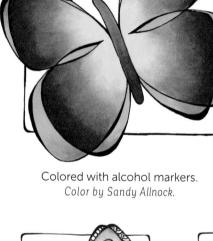

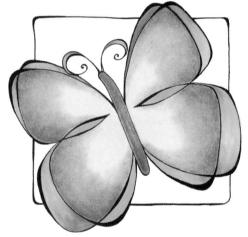

Colored with colored pencils and brush pens.

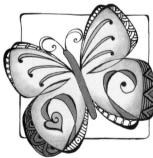

Patterned with black pen. Colored with colored pencils, gel pens, and brush pens.

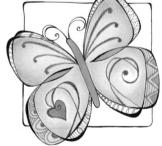

Patterned with colored pens. Colored with colored pencils, brush pens, and colored pens.

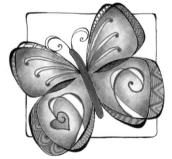

Patterned with black gel pen. Colored with colored pencils and brush pens.

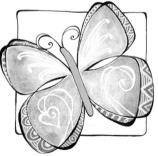

Patterned with white gel pen. Colored with water-soluble pencils and brush pens.

When I color my designs, I love to contrast areas of matte color with areas that shimmer and shine, and I often add touches of metallic and glitter. I gravitate toward a bright palette, but encourage you to work with whatever colors sing to your soul.

Be sure to check out the finished samples on the next few pages to see how different color and creativity enthusiasts from around the globe interpret the same design.

Colored pencils

Brush markers

Watercolors

Markers

Alcohol markers

Gloss and metallic pens

Glitter and neon pens

Matte and gel pens

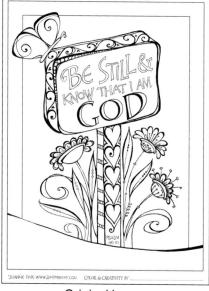

Original image

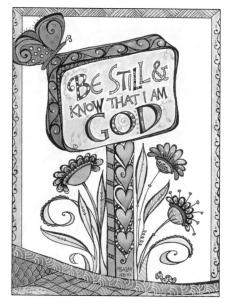

Colored pencils, pens, gel pens, markers. Color θ creativity by Mary Anne Fellows.

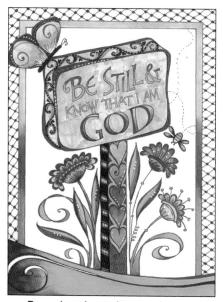

Pens, brush markers, gel pens. Color θ creativity by Sephra Travers.

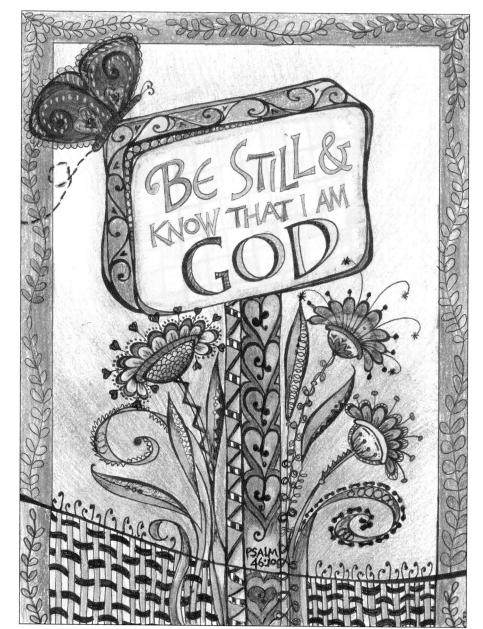

Markers, gel pens, pastels. Color θ creativity by Gail Beck.

Markers, colored pencils, gel pens, pastels. Color θ creativity by Puneet Sekhon.

Colored pencils, pens, crayons. Color & creativity by Amrit Kaur.

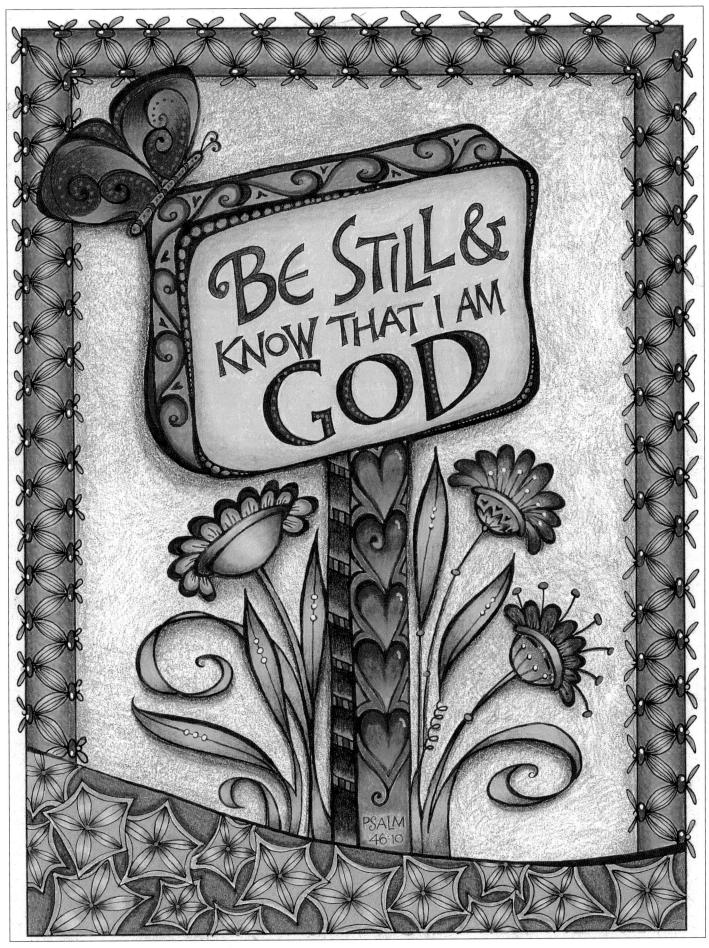

Colored Pencils, pens, gel pens. Color & creativity by Leitha Hunt.

Original image

Colored pencils, pens, crayons. Color θ creativity by Amrit Kaur.

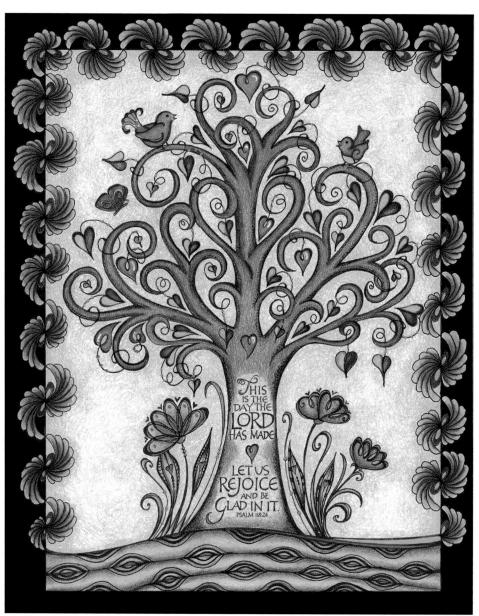

Colored pencils, gel pens, pens. Color & creativity by Leitha Hunt.

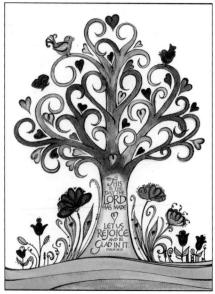

Colored pencils, oil pastels. Color *θ* creativity by Karen Logeman.

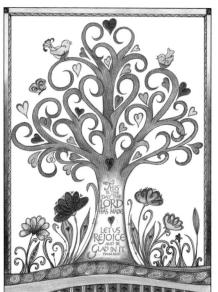

Colored pencils, pens. Color *θ* creativity by Sephra Travers.

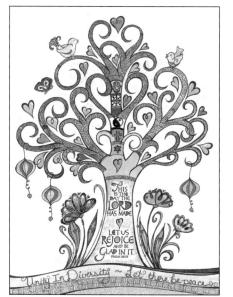

Colored pencils, pens, gel pens, markers. Color θ creativity by Mary Anne Fellows.

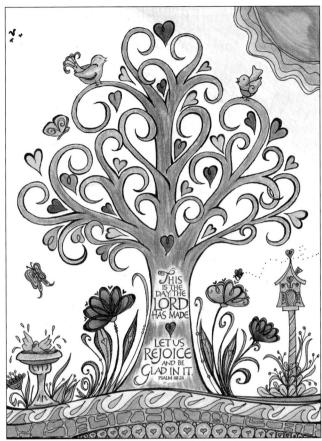

Pens, gel pens, water color markers, colored pencils. Color & creativity by Terri Brown.

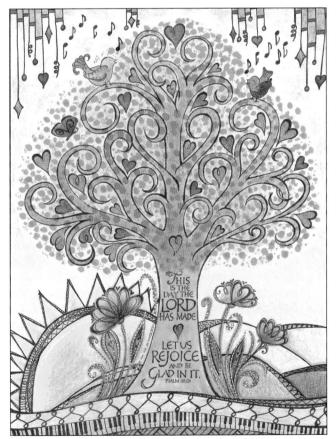

Colored pencils, pens, markers, gel pens. Color θ creativity by Kathryn Leonard.

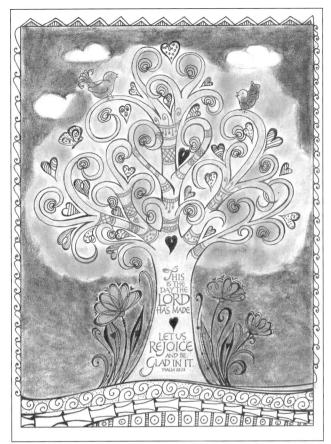

Gel pens, pastels. Color & creativity by Puneet Sekhon.

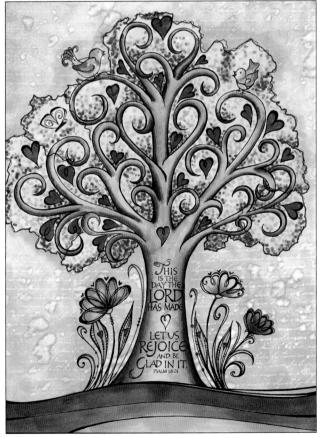

Copic markers, Copic Activator Spray, stamps, Color & creativity by Helga Cuypers.

Original image

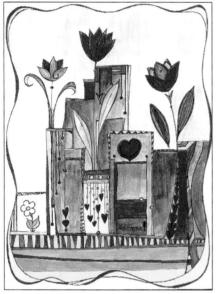

Watercolors, pens, gel pens. Color θ creativity by Sue Rems.

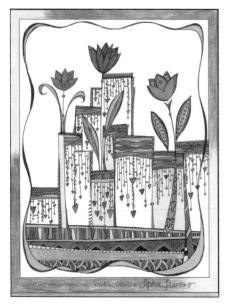

Colored pencils, pens, gel pens. Color *θ* creativity by Sephra Travers.

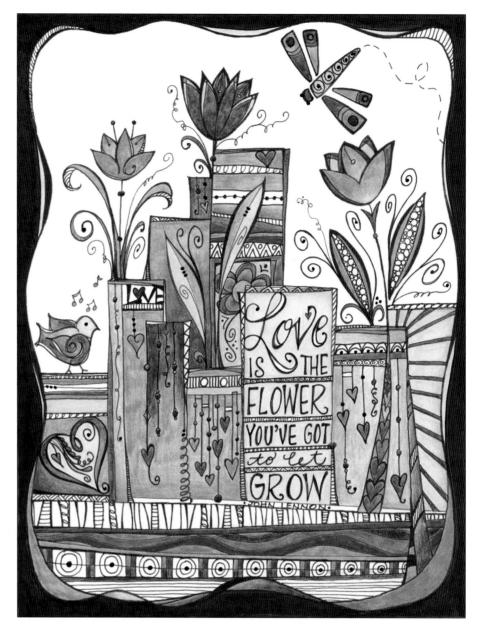

Markers, pens, gel pens. Color θ creativity by Alison Clement.

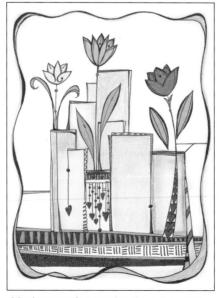

Markers, soft pastel colored pencils. Color θ creativity by Wanda Radler.

Colored pencils, pens, gel pens, watercolor markers. Color & creativity by Terri Brown.

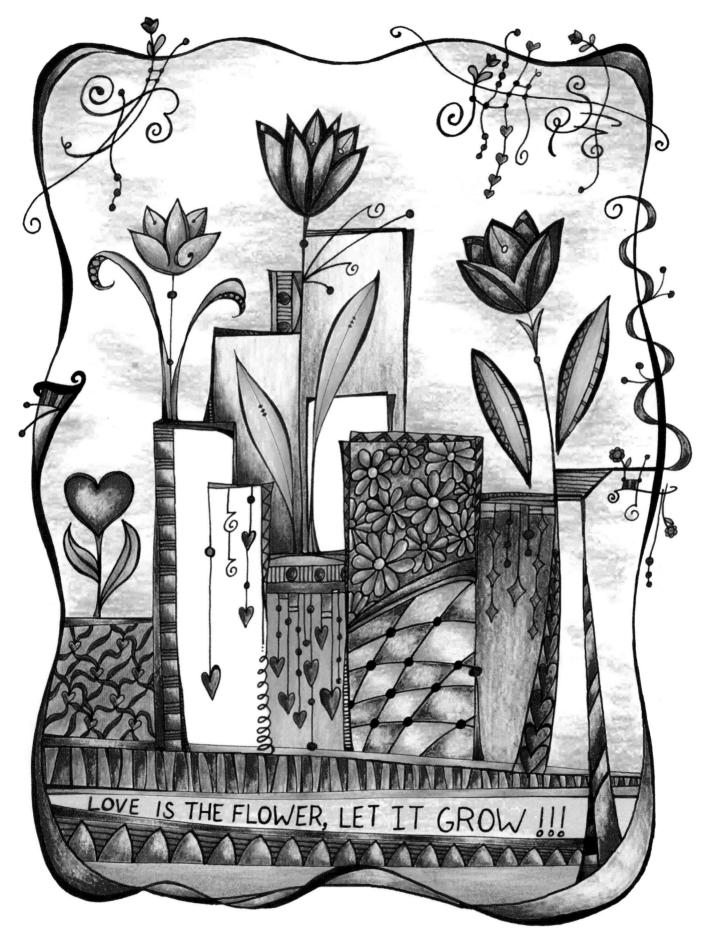

Colored pencils. Color θ creativity by Ranae' Davidson.

Colored pencils, pens, gel pens, markers. Color θ creativity by Terri Brown.

Pastel crayons. Color & creativity by Ranae' Davidson.

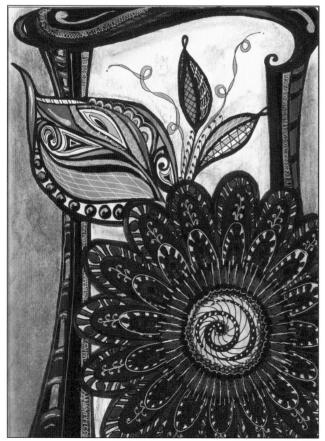

Markers, gel pens, pastels. Color *θ* creativity by Gail Beck.

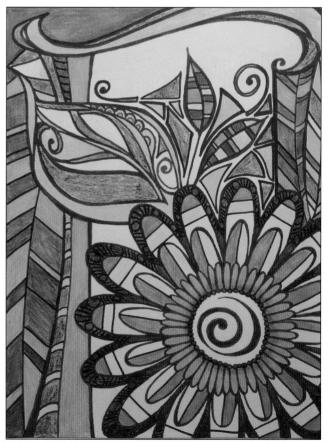

Colored pencils, markers, sand eraser, fluorescent pencils. Color & creativity by Jennifer Priest.

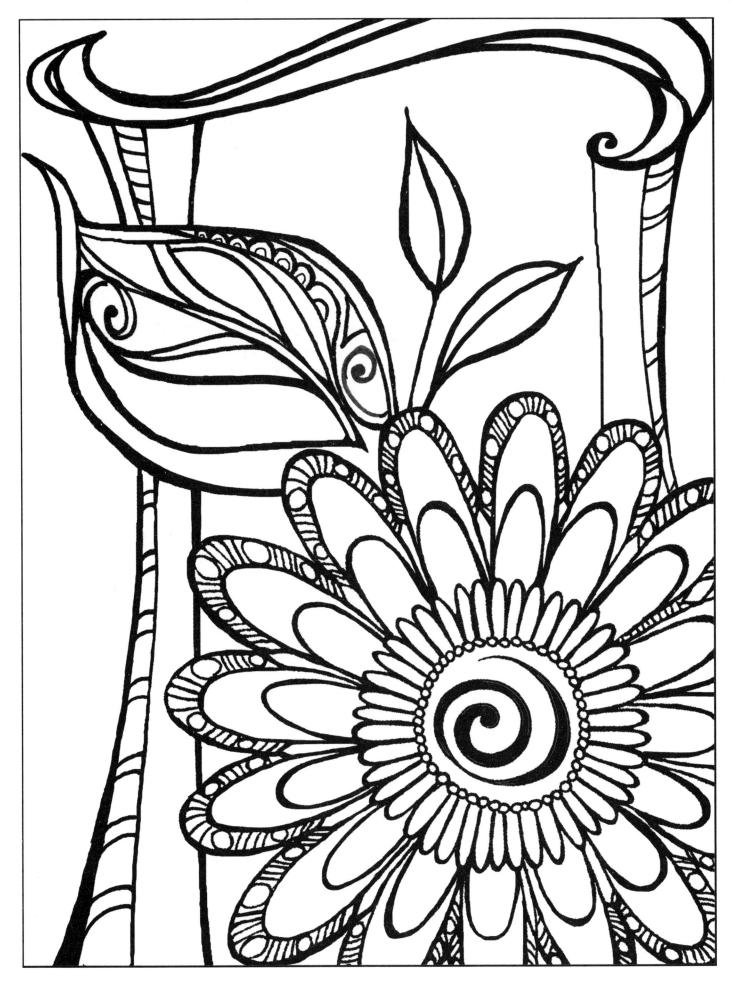

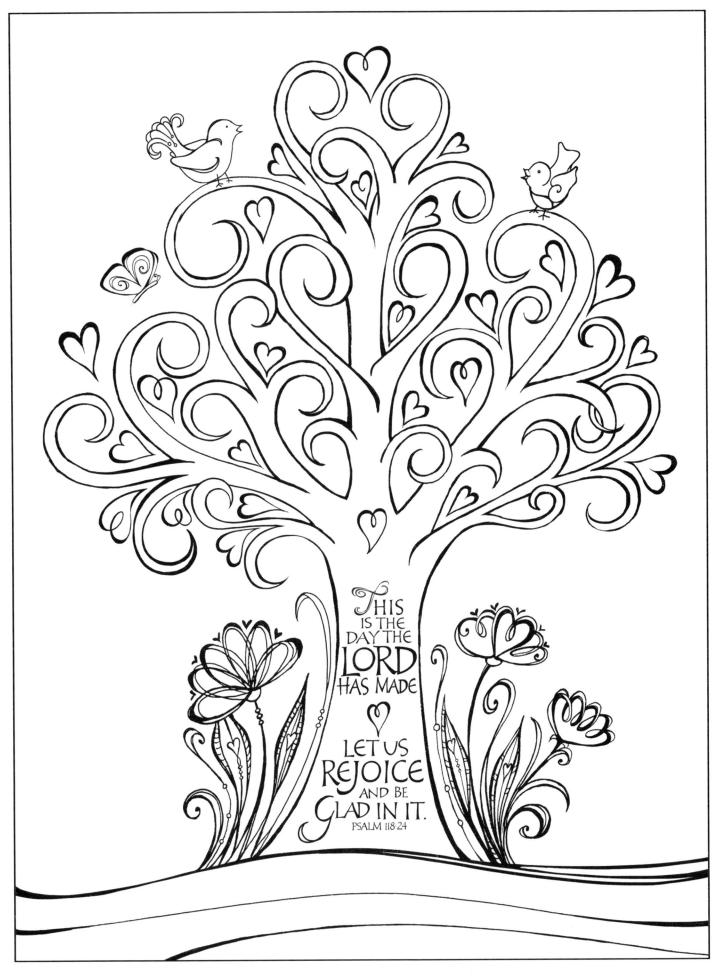

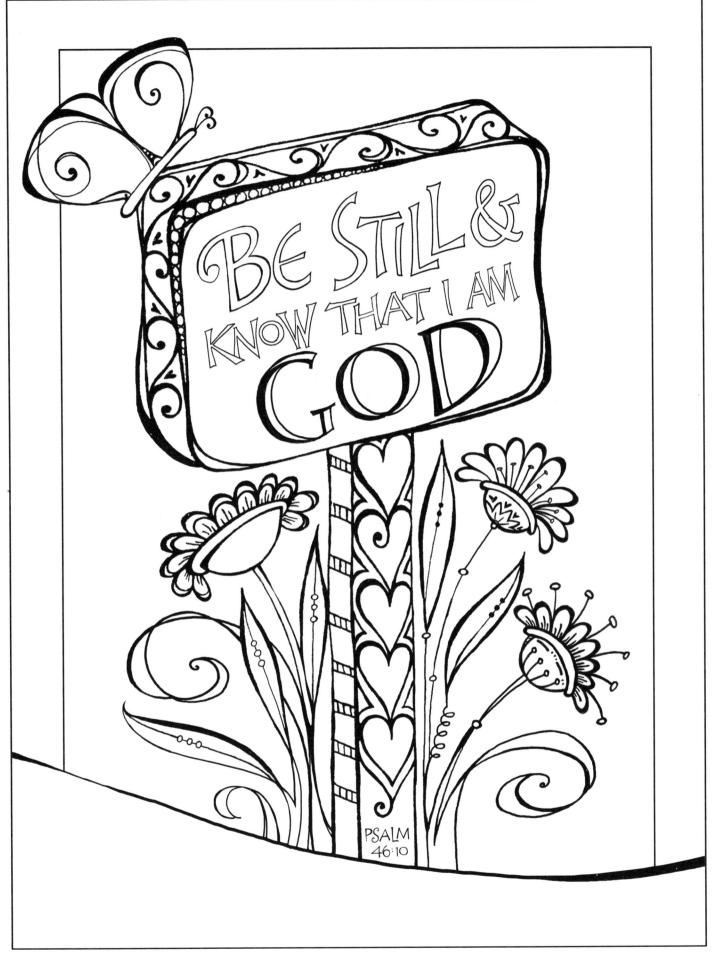

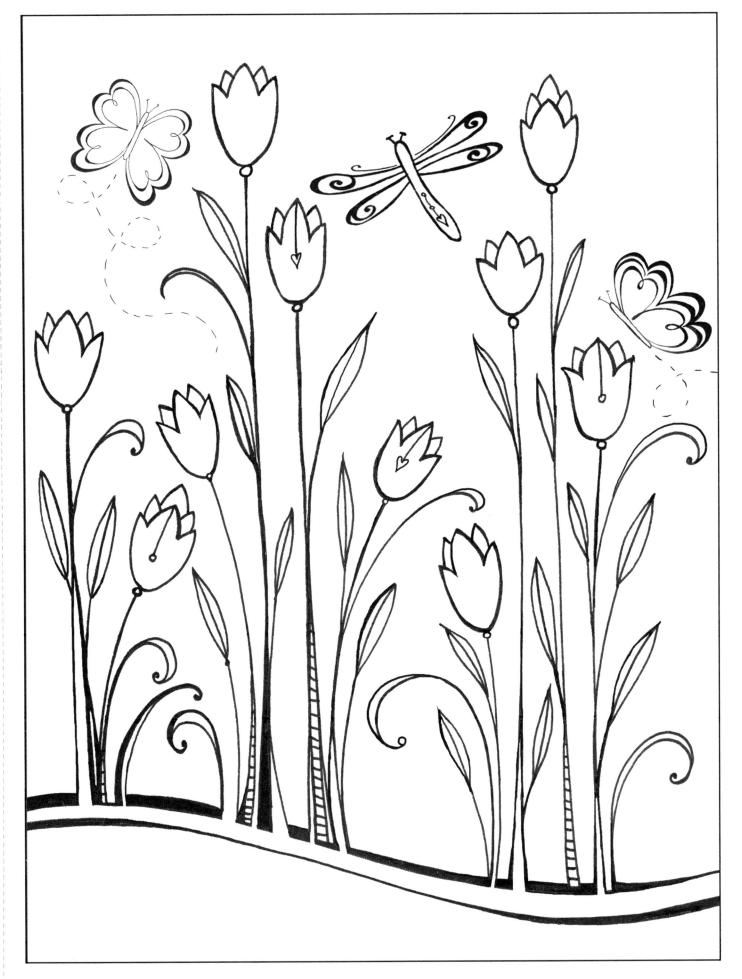

FAICH Hope and the greatest of these is love. 1 Corinthians 13:13

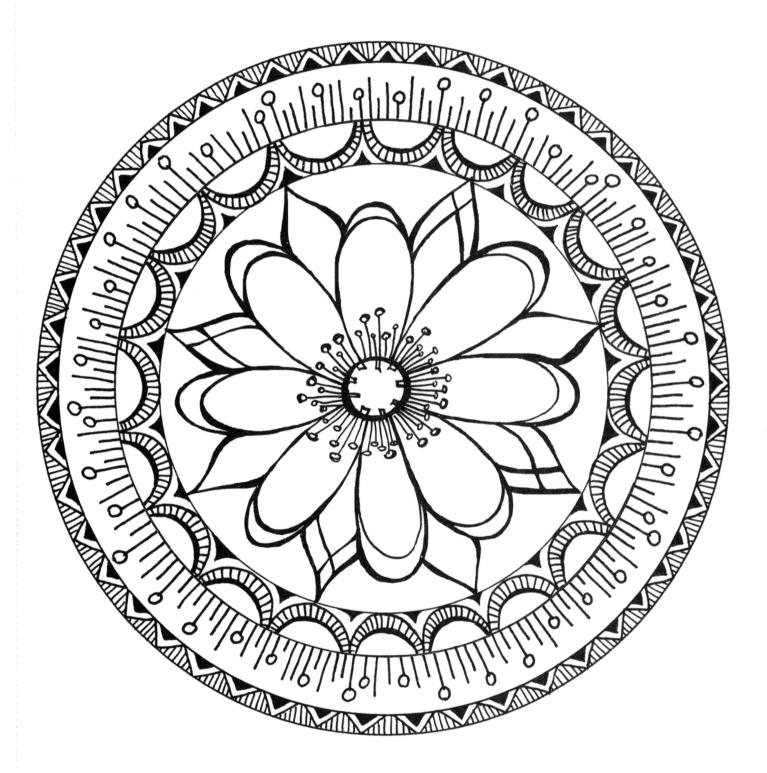

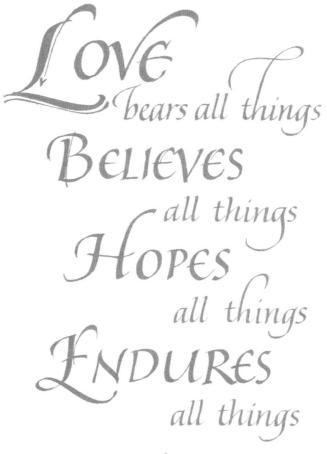

1 Corinthians 13:7

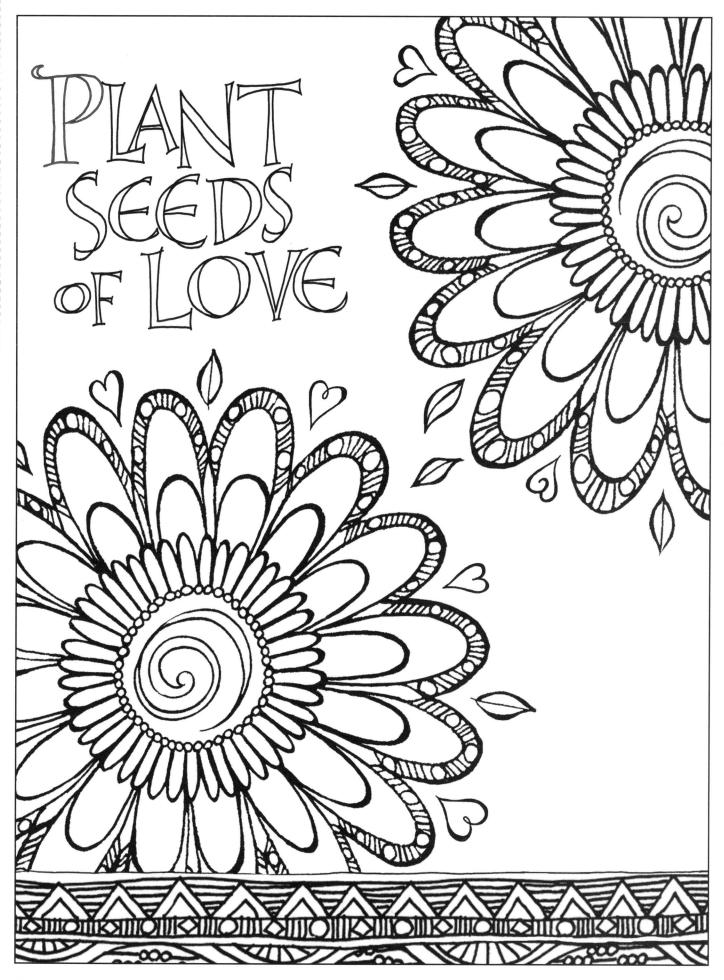

"JOANNE FINK WWW.LAKESIDE-DESIGN.COM COLOR & CREATIVITY BY

1 Corinthians 13:8

[&]quot;JOANNE FINK WWW.LAKESIDE-DESIGN.COM COLOR & CREATIVITY BY

with all your HEART

Proverbs 3:5-6

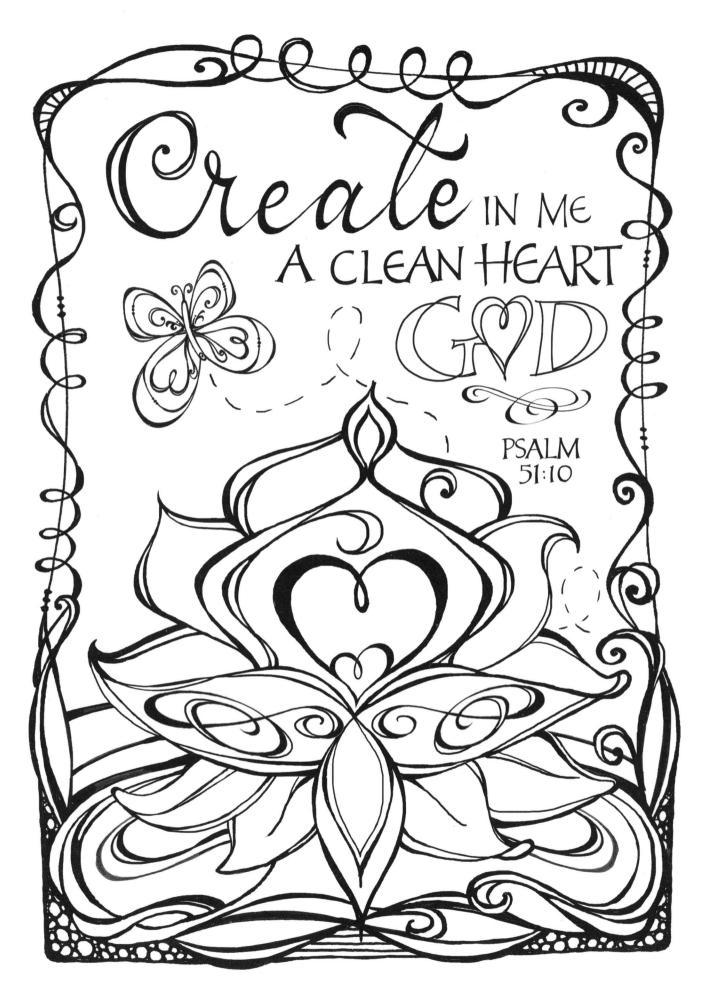

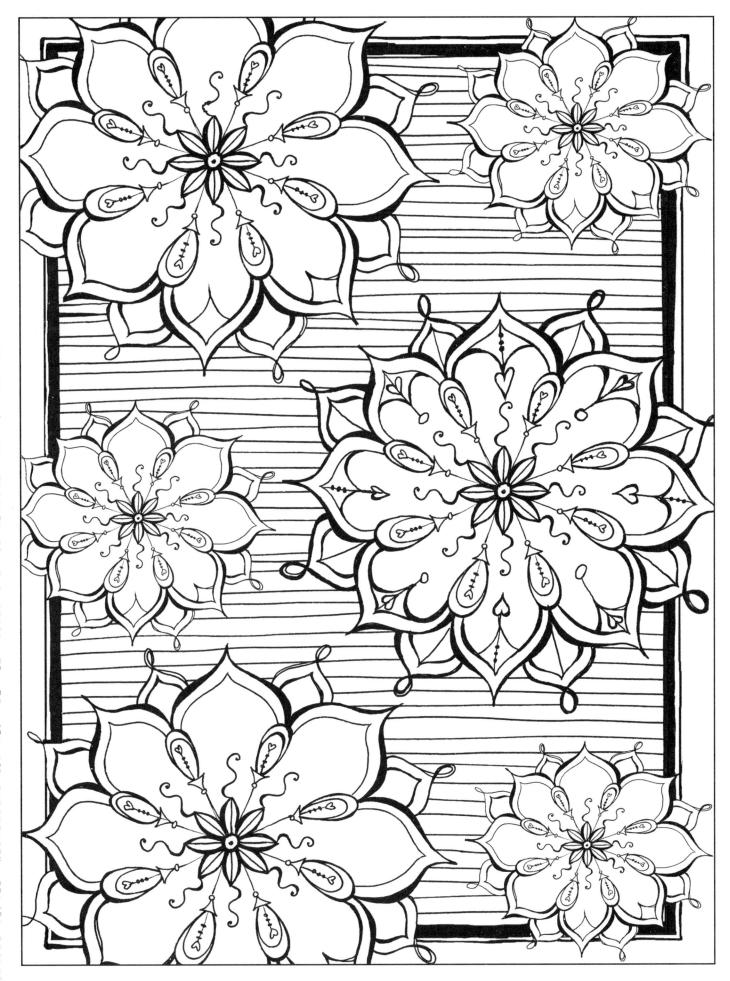

As for me and my house we will serve the LORD. Joshua 24:15

PSALM 46:10

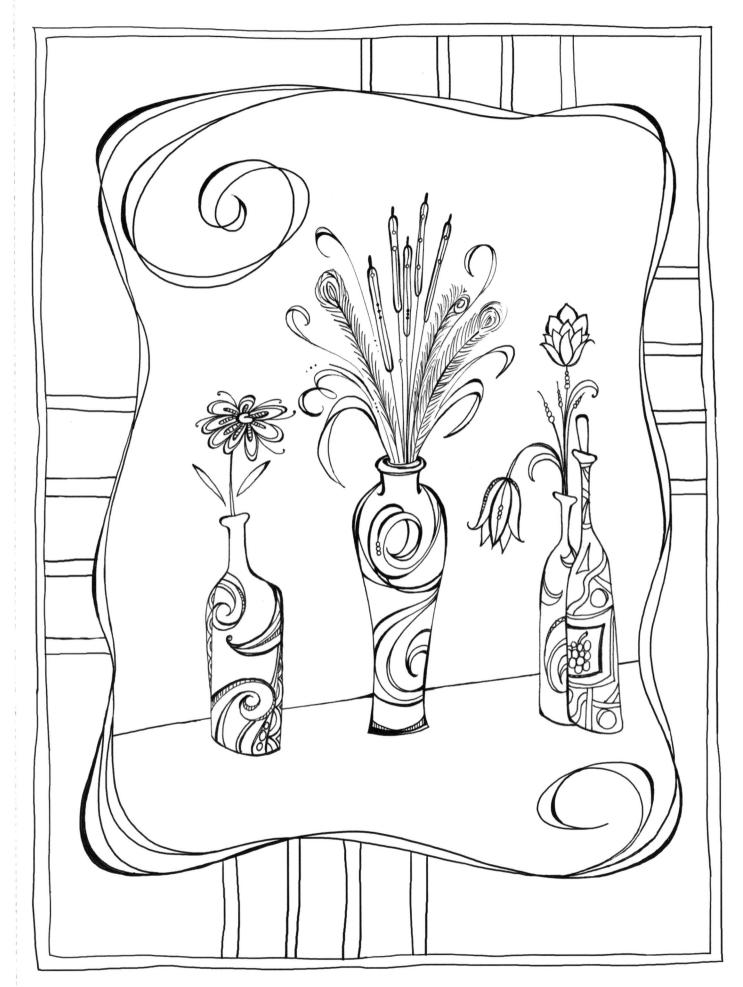

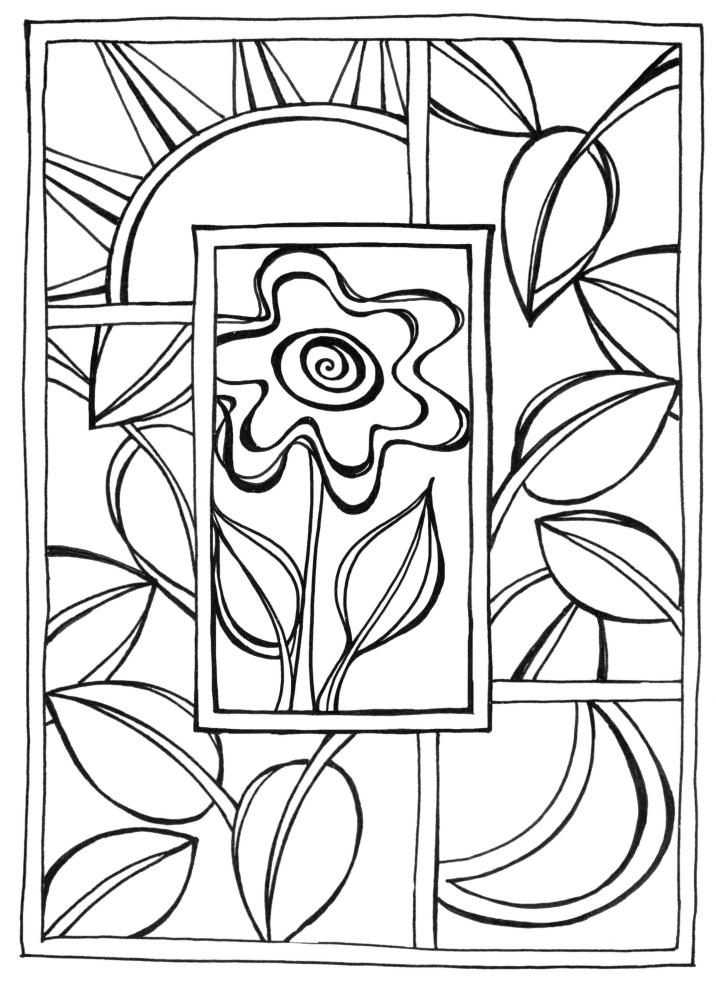

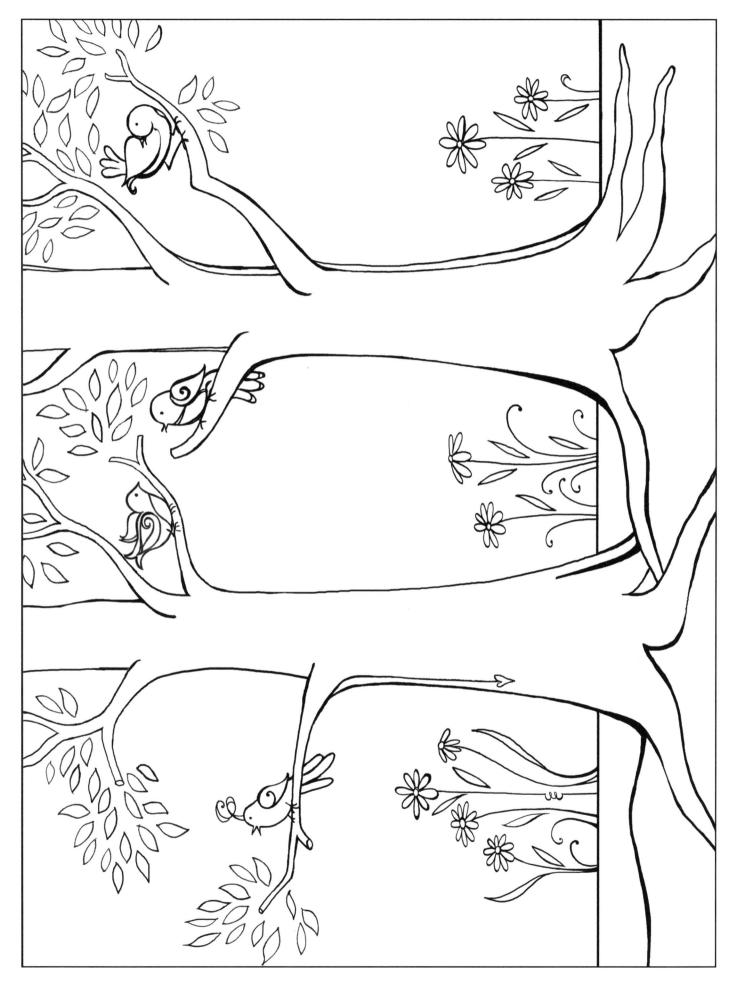

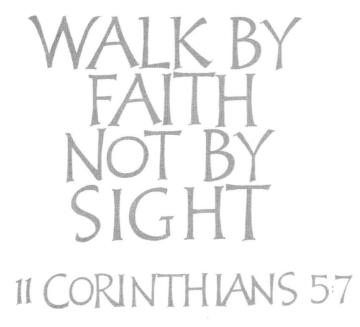

Set me as a seal upon your HEART.

SONG OF SOLOMON 8:16

THOSE WHO HOPE IN THE CORD WILL RENEW THEIR STRENGTH

ISAIAH 40:31

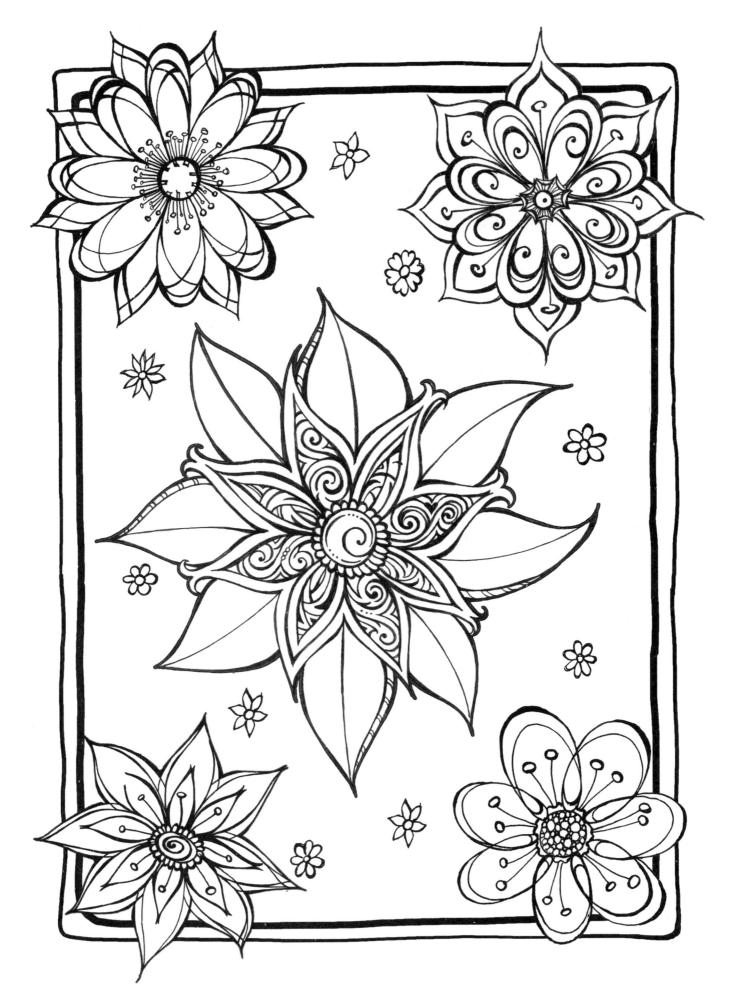

ì

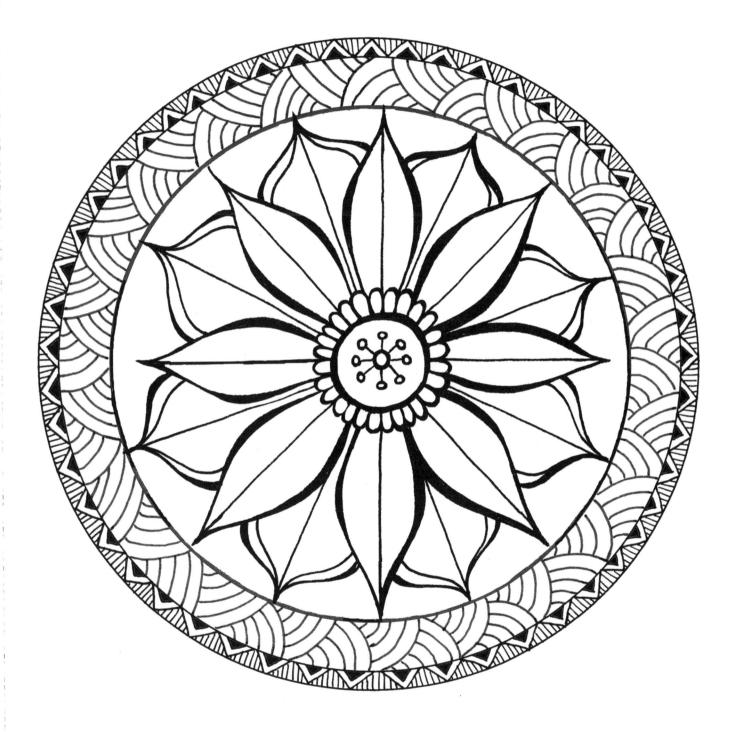

"JOANNE FINK WWW.LAKESIDE-DESIGN.COM COLOR & CREATIVITY BY _____

1 Corinthians 13:4

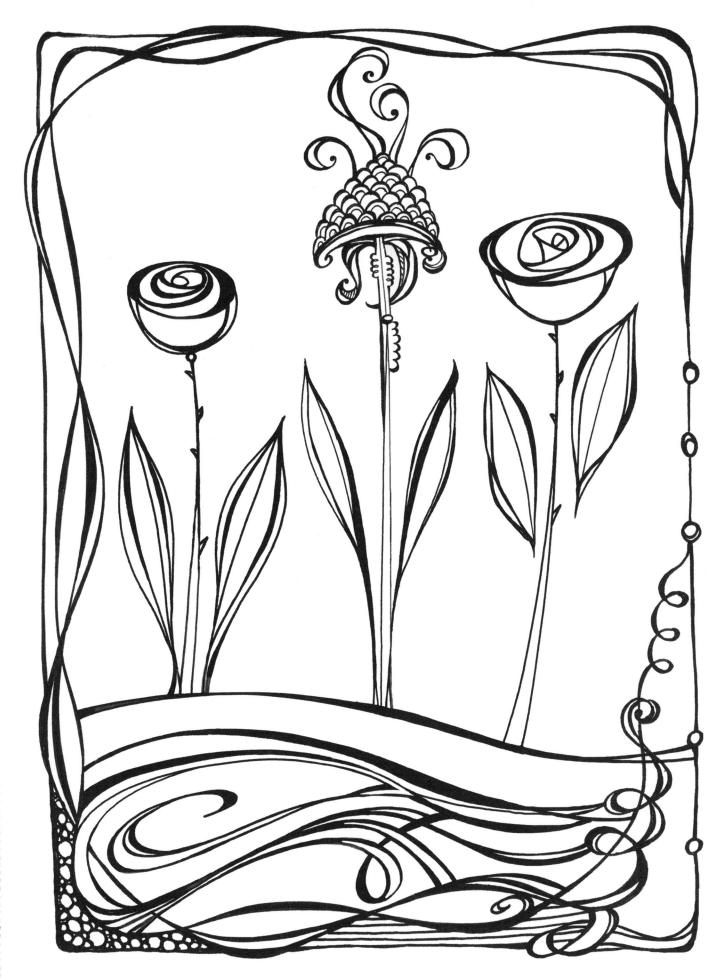

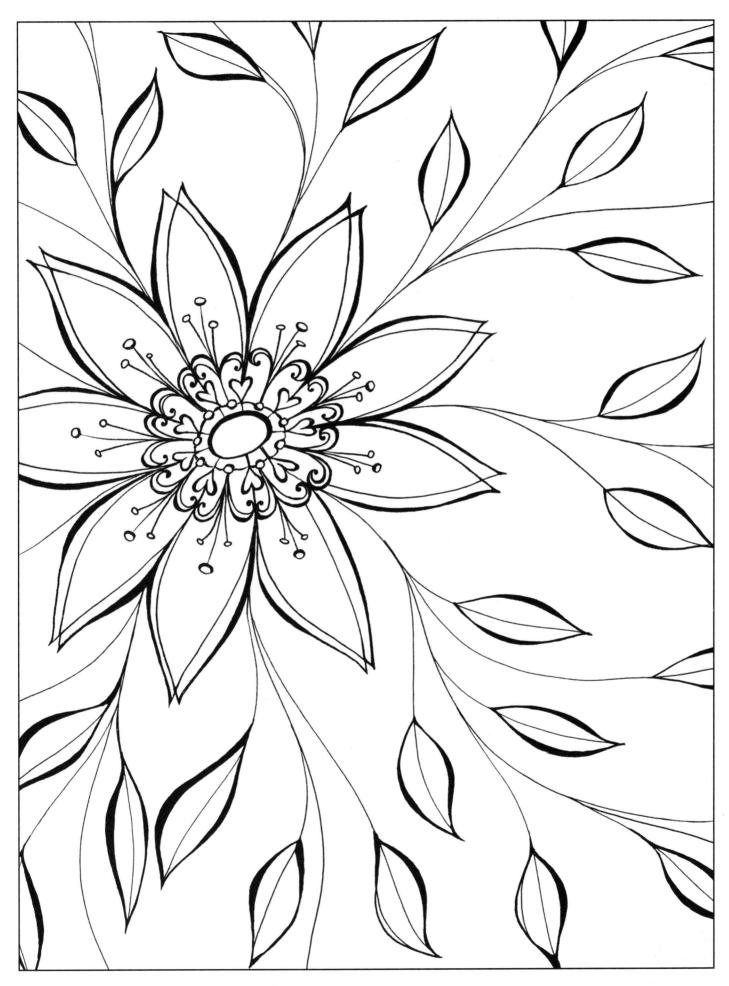

ASK

and it shall be given to you

5 EEK

and you shall find

KNOCK

and the door shall be opened to you

Matthew 7:7

I will hope continually. Psalm 71:14

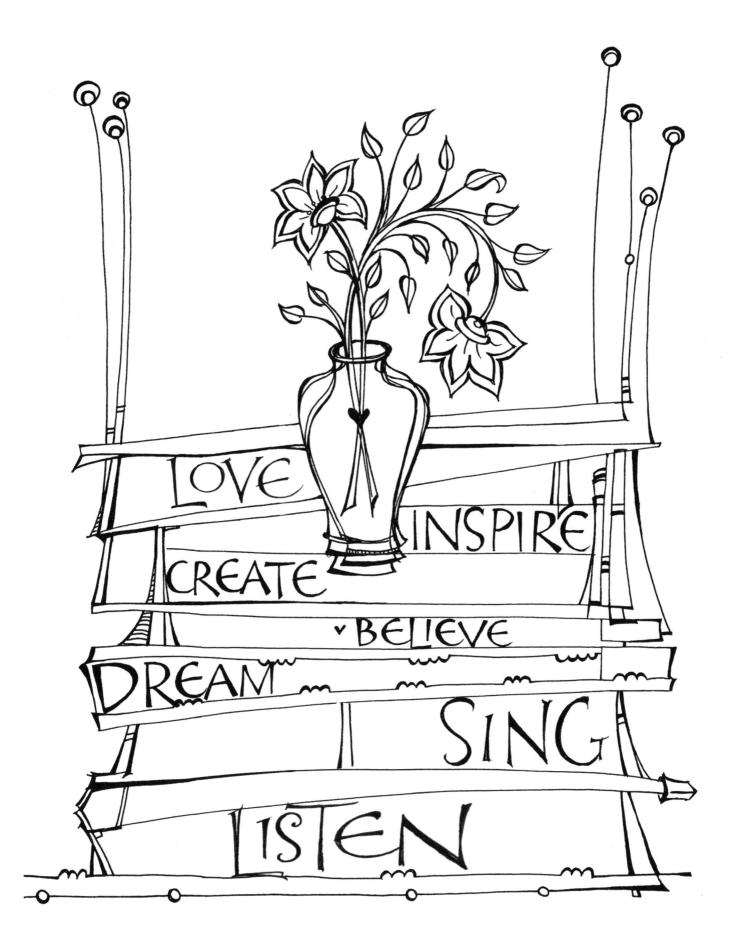

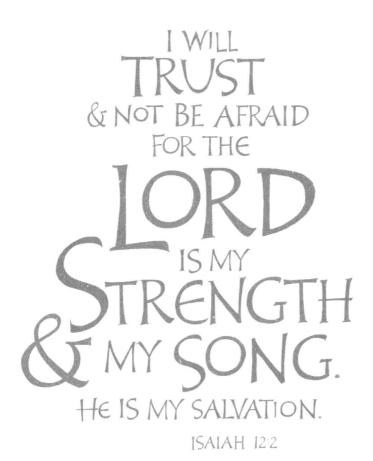

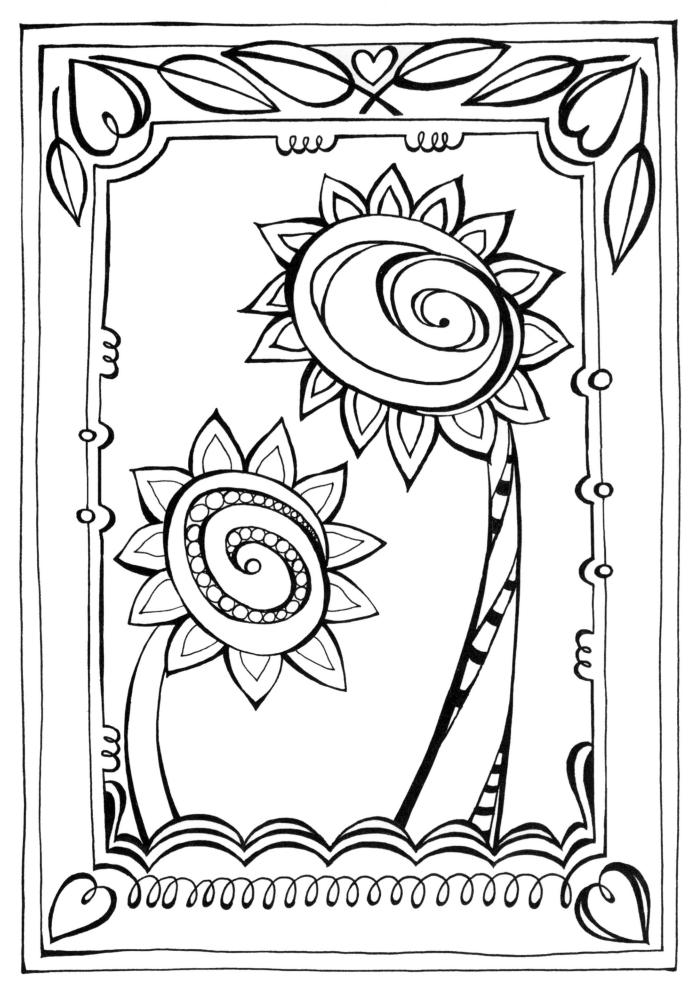

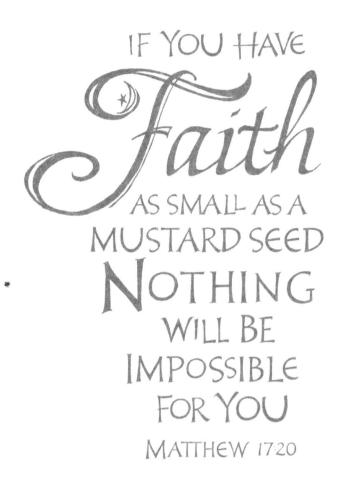

The faithful shall abound with blessings. Proverbs 28:20